JAMES

WHAT YOU DO MATTERS

BIBLE STUDY GUIDE + STREAMING VIDEO

FIVE SESSIONS

MARGARET FEINBERG

HarperChristian Resources

James Study Guide

© 2023 by Margaret Feinberg

Published in Grand Rapids, Michigan, by HarperChristian Resources. HarperChristian Resources is a registered trademark of HarperCollins Christian Publishing, Inc.

Requests for information should be sent to customercare@harpercollins.com.

ISBN 978-0-310-16707-5 (softcover)
ISBN 978-0-310-16708-2 (ebook)

HarperChristian Resources titles may be purchased in bulk for church, business, fundraising, or ministry use. For information, please email ResourceSpecialist@ChurchSource.com.

Author is represented by The Christopher Ferebee Agency, www.christopherferebee.com.

First Printing December 2023 / Printed in the United States of America

CONTENTS

WHAT YOU DO MATTERS

Welcome, friend!

I've got a question for you. When you're facing a hardship, challenge, or uncertainty, where do you turn for answers in the Bible? Do you flip open the book and simply see where the pages land? Or do you know what book of the Bible will offer the comfort, encouragement, and clarity you need?

Other than the Gospels, which are packed with the teachings of Christ, do you know which book of the New Testament sounds the most like Jesus?

It's James! Perhaps we shouldn't be surprised. The author of this book, James, was the sibling of Jesus. They were raised by the same mom, played in the same yard, and shared the same meals around the table. Yet despite watching his brother perform mighty miracles and deliver life-changing teachings, James remained a skeptic for quite some time.

But something about the suffering, death, and resurrection of Jesus changed everything for James. He became a vibrant believer, and one of the leading voices in the Church of Jerusalem.

He penned his letter to Jewish believers who were experiencing persecution and poverty. Many had been seduced by popular culture and had fallen prey to division and quarrels. Throughout his letter, James echoes the refrains of his brother Jesus, especially those found in the Sermon on the Mount. He knows that it's easy to get sidelined in life—by struggles, disappointments, judgments, distractions, and divisions.

James' letter is a rallying cry to listen to God's words, and to look for every opportunity to live them out. Genuine love of God expresses itself through faith *and* action. What we do matters.

I can't wait to take this journey through James with you!

Margaret Feinberg

HOW TO USE THIS GUIDE

Group Information and Size Recommendations

The *James* video study is designed to be experienced in a group setting such as a Bible study, small group, or Sunday school class. Of course, you can always work through the material and watch the videos on your own if a group is unavailable. Maybe call a few friends or neighbors and start your own!

After opening with a short activity, you will watch the video session and participate in a time of group discussion and reflection on what you're learning both from the video teaching and from the personal Bible study between meetings. This content is rich and takes you through the entire book of James, so be prepared for a full experience of the depth of Scripture.

If you have a larger group (more than twelve people), consider breaking up into smaller groups during the discussion time. It is important that members of the group can ask questions, share ideas and experiences, and feel heard and seen— no matter their background or circumstance.

Materials Needed and Leading a Group

Each participant should have his or her own study guide. Each study guide comes with individual streaming video access (instructions found on the inside front cover). Every member of your group has full access to watch videos from the convenience of their chosen devices at any time—for missed group meetings, for rewatching, for sharing teaching with others, or for watching videos individually before meeting if your group is short on meeting time. This gives your group the flexibility to make the experience doable no matter your unique circumstances.

This study guide includes video outline notes, group discussion questions, a personal Bible study section for between group meetings, coloring pages, and Scripture memory cards to deepen learning between sessions.

There is a Session by Session Overview in the back of each study guide so anyone can lead a group through this study.

Timing

The timing notations—for example, 20 minutes—indicate the length of the video segments and the suggested times for each activity or discussion. Within your allotted group meeting time, you may not get to all the discussion questions. Remember that the *quantity* of questions addressed isn't as important as the *quality* of the discussion.

Using the Session by Session Overview in the back of the guide to review the content overview of each session and the group discussion questions in advance will give you a good idea of which questions you want to focus on as a leader or group facilitator.

Facilitation

Each group should appoint a leader or facilitator who is responsible for starting the video and keeping track of time during the activities and discussion. Facilitators may also read questions aloud, monitor discussions, prompt participants to respond, and ensure that everyone has the opportunity to participate.

Opening Group Activity

Depending on the amount of time you meet and the resources available, you'll want to begin the session with the group activity. You will find these activities on the group page that begins each session. The interactive icebreaker is designed to be a catalyst for group engagement and help participants prepare and transition to the ideas explored in the video teaching.

The leader or facilitator will want to read ahead to the following week's activity to see what will be needed and how participants may be able to contribute by bringing supplies or refreshments.

GROUP STUDY

HOW YOU RESPOND TO HARDSHIP MATTERS

Opening Group Activity

(10–15 MINUTES)

In upcoming sessions, we'll have group activities. But for this opening session, let's start with some questions. Everyone comes to a gathering like this for different reasons and with different goals and hopes. Take a few moments to discuss the following:

- ☑ What prompted you to come to this study group?
- ☑ What do you hope to get out of this time together?
- ☑ What do you hope to get out of studying James?

Bonus: Take a photo of your group and send it to hello@margaretfeinberg.com. She and her team want to see your smiling faces and pray for your group.

Session One Video

(21 MINUTES)

Leader, stream the video or play the DVD.

As you watch, take notes while thinking through:

What caught your attention?

What surprised you?

What made you reflect?

Video Notes

☑ James' letter sounds more like Jesus than any other New Testament letter

☑ Who said it: James or Jesus?

☑ Practice a defiant joy

☑ Perseverance is faith stretched out

☑ Ask God to lavish you with wisdom

☑ Every good and perfect gift is from above

SCRIPTURE covered in this teaching session:
James 1:1–6, 17

Group Discussion Questions

(30–45 MINUTES)

Leader, read each numbered prompt and question to the group and select volunteers for Scripture reading.

1. What challenged, encouraged, or surprised you about the game, *Who Said It: James or Jesus?*

2. Select a few volunteers to read Matthew 13:55; John 7:1–5; 1 Corinthians 15:3–7; and James 1:1.

 Discuss the following:

 What do each of these passages reveal about James?

 What do you think would have been some of the joys and challenges of being Jesus' sibling?

3. **Select a few volunteers to read Matthew 5:11–12 and James 1:2–4.** Discuss the following:

What parallels do you see between Jesus' Sermon on the Mount and James' instruction?

What's one challenge or hardship you've faced that has really stretched you? How did that difficult time impact your faith, your relationships, and your outlook on life?

In what ways did you grow stronger, more mature, or more in love with God and others?

Where are you still needing to heal from that experience?

4. Margaret teaches:

> " Practicing a defiant joy is an active engagement of the mind in which we choose to place our trust in the character and competence of God. Practicing a defiant joy means that no matter what we're facing, we remain suspicious that God is up to something good. Because when we look for the goodness of God, we will find him. "

Describe a hard season when you found God's goodness shining through in an unexpected way.

What are some practical ways you can cling to the goodness of God in hard times?

5. When you're in the midst of a challenge or hardship, which of the following do you tend to go to first for help and wisdom? Circle your top three responses and rank them.

_____ Internet _____ Friends _____ Self-help book
_____ Spouse _____ Instagram _____ Pastor
_____ God _____ Online video _____ Influencer
_____ Family _____ Counselor _____ Other _____

Where does God rank among the places you turn to quickest?

What hinders you from going to God first?

How can you overcome these hindrances?

6. Margaret gave two tactics based on James' teaching for what to do when hardship happens:

<div align="center">

Practice a Defiant Joy

and

Ask God to Lavish You with Wisdom

</div>

Go around the group answering a selection of the following questions:

Which of these tactics is easiest for you to remember and implement when facing hardship, and which is most difficult? Explain.

Which would help you most in the challenges you're facing now? Explain. What's stopping you from implementing this tactic?

Close in Prayer

Consider the following prompts as you pray together for:

☑ Defiant joy in the midst of hardship

☑ Wisdom that comes from above

☑ Eyes to see the goodness of God

Good stands tippytoe ready to lavish you with wisdom, and it's his joy to give it to you!

Preparation

To prepare for the next group session (Session 2):

☑ **Read James 1:22–27.**

☑ Tackle the three days of the Session One Personal Study Time.

☑ Memorize this week's passage using the Scripture memory coloring page. As a bonus, look up the Scripture memory passage in different translations and take note of the variations.

☑ Ask members to bring something for the next session's Opening Group Activity—it's a fun one! See page 38 for the list of needed items.

**Every good and perfect gift
is from above, coming down from the
Father of the heavenly lights, who does
not change like shifting shadows.**

James 1:17

PERSONAL STUDY TIME

HOW YOU RESPOND TO HARDSHIP MATTERS

DAY 1
Background of James

If you look for the name James in the New Testament, you'll find several, including:

- James, the brother of John and son of Zebedee, one of the twelve apostles (Mark 3:17; Luke 5:10; Luke 9:28; Acts 1:13).
- James, the son of Alphaeus, one of the twelve apostles (Mark 3:18; Luke 6:15; Acts 1:13).
- James, the father of Judas (not Iscariot) (Luke 6:16; Acts 1:13).
- James, the brother of Jesus (Matthew 13:55; Mark 6:3; Galatians 1:19).

As his brother, the James we're studying had a unique, close-up look at many of the growing-up years of Jesus. The Gospels record very few details about Jesus' youth beyond his birth, except one story: when the family travels to Jerusalem for the Festival of Passover. All of the children—including James—would have gone, too. That's when Mary and Joseph discover that Jesus is missing.

1. **Read Luke 2:41–52.**

 What does the family—including James—likely have to endure because of Jesus' disappearance?

 What do you think it's like for Jesus' family—including James—to discover where Jesus has been and what he has been doing?

How does Jesus' mother respond to the incident?

If you were James, how would you respond to the incident?

2. Read Mark 3:20–35.

What stands out to you about this interaction between Jesus and his family—including James?

On the continuum below, mark how challenging it would have been for you to be Jesus' sibling.

❶——❷——❸——❹——❺——❻——❼——❽——❾——❿

I would have
enjoyed being
Jesus' sibling.

I would have
struggled being
Jesus' sibling.

3. **Read Acts 1:14.**

 What has changed in the way Jesus' family members—including James—respond to Jesus?

After Jesus' suffering, death, and resurrection, James becomes a key leader in the Jerusalem church. His role expanded after Peter fled from Jerusalem (Acts 12:1–17) and is implied in Galatians 1:19. James' influence is displayed when a debate breaks out over whether Gentiles can be accepted by the whole Jerusalem council.

4. **Read Acts 15:13–21.**

 What is James' argument?

 How does James' response allow the early church to grow?

James, whose name is the equivalent of Jacob in Hebrew, was known as James the Just or James the Righteous by those in Jerusalem.

5. Look up the following passages and note what they reveal about James and how he is regarded in the church and by the disciples.

Scripture	Details about James and How He Is Regarded
Acts 12:16–17	
Acts 15:12–21	
Acts 21:17–19	
Galatians 1:18–19	
Galatians 2:9–10	

Reflecting on these passages, write two to three sentences describing James' transformation and leadership in the early church in the space below.

DAY 2
James 1:1–8

James, the brother of Jesus, addresses fellow believers as his siblings or "brothers and sisters" (James 1:2) throughout his letter. They're scattered outside of Israel because of persecution (Acts 11:19). These Jewish Christians are living in exile, torn away from the people, the culture, the food, and the way of life they once knew. Many are living in poverty.

1. **Read James 1:1–4.**

 On the continuum below, mark how easy or difficult it is for you to respond to hardship like James instructs.

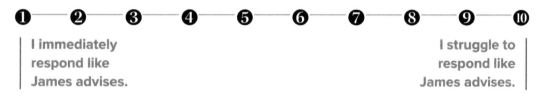

| ❶ | ❷ | ❸ | ❹ | ❺ | ❻ | ❼ | ❽ | ❾ | ❿ |

I immediately respond like James advises.

I struggle to respond like James advises.

 What makes it most challenging for you?

2. **Which of the following are your unhealthy tendencies when you're facing hardship or suffering? Circle all that apply.**

 Avoidance Withdrawal Negative thought spirals
 Self-medication Excessive worrying Feeling helpless
 Risky behaviors Blaming yourself Other _____

Which of the following are your healthier tendencies when you're facing hardship or suffering? Circle all that apply.

Deeper prayer

Showing grace to yourself
and others

Growing in dependence on Christ

Leaning into community

Setting realistic goals

Taking time to reflect

Clinging to God's promises

Learning from mistakes

Becoming more vulnerable

Engaging in positive self-talk

Seeking Biblical counseling

Being patient with yourself
and others

Below is an illustration of what James teaches:

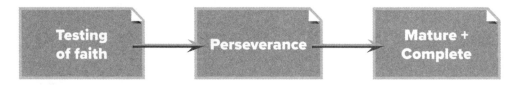

Testing of faith → Perseverance → Mature + Complete

3. **What's the biggest challenge you've faced in your life, and how did it help you grow in perseverance?**

How did your faith change or mature through that experience?

While we should ask for wisdom from God, the Father of heavenly lights, in whom there is no shifting shadow (James 1:17), in *every* area of our lives, it's worth noting that James' call to ask for wisdom comes within the context of facing adversity. While hardship happens, we can forget to go to God first, even though we know he wants to lavish us with wisdom.

4. **Read James 1:5–8.**

Describe a time when you prayed for wisdom and got it.

What are you doing to regularly remind yourself of who God is and what he's like?

5. What do the following passages reveal about the wisdom of God? Look up the passages and fill in the chart below.

Scripture	Details about God's Wisdom
Proverbs 2:1–11	
Proverbs 3:13–15	
Proverbs 4:7–9	
Proverbs 9:10	

What, if anything, hinders you from trusting God's goodness and guidance?

In the space below, write a prayer asking God to give you both perseverance and wisdom for the challenges you're facing.

DAY 3

James 1:9–18

Sometimes when we're in the midst of hardship, it's easy to look to others who, from all outward appearances, seem to have it better. Yet James reminds us that God's perspective and economy are much different from our own.

One theme found throughout Scripture is known as "the great reversal," whereby God lifts up the humble and humbles the proud.

1. **Read James 1:9–12 and Matthew 5:3–5.**

 What parallels do you see between James' teaching and this portion of Jesus' Sermon on the Mount?

 How has wealth or poverty impacted your relationship with God?

 What steps do you need to take to redirect your faith toward God and away from money?

2. **Read James 1:13–15.**

Who do you tend to blame when you're facing temptation?

Who do you tend to blame when you give in to temptation?

James 1:2–4, 12 teaches:

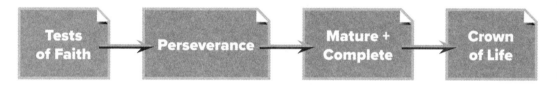

Tests of Faith → Perseverance → Mature + Complete → Crown of Life

James 1:14–15 teaches:

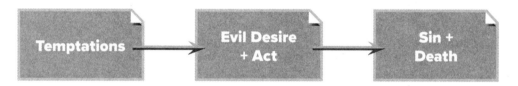

Temptations → Evil Desire + Act → Sin + Death

Reflecting on these two different outcomes, how do tests of faith and temptations differ?

James addresses his readers as "brothers and sisters" (1:2) and now adds "my dear" (1:16). He's writing to the family of God, highlighting men *and* women! This is a phrase he'll continue to build on throughout his letter. James wants his readers to know that he, and God, are looking out for their best interests.

A foundational belief in the goodness of God is crucial to understanding James' letter. James doesn't want us to miss out on all the good that God has for us as passionate followers of Jesus.

3. **Read James 1:16–18.**

 Make a list of the characteristics of God in this passage.

 How have you experienced each one?

> James refers to the early harvest when he says we are "a kind of first fruits of all he created" (James 1:18). There's much more to come!

How have you experienced God consistently lavishing good and loving gifts on you? Write a prayer of gratitude in the space below.

Though we're only partially through the first chapter, it's clear that James is a direct communicator who not only challenges us to ask—and keep asking—for wisdom, but also shares practical, implementable pieces of godly wisdom along the way. Again, he refers to his readers as "my beloved brothers and sisters" (1:19). This serves to soften his readers for his strong words and remind them of his familial concern and care.

4. Read James 1:19–20.

In the chart below, rank the following from 1 to 3 based on which is easiest for you and which is most challenging. Then explain in what ways each of them is challenging for you.

James' Instruction	Ranking of Easiest (1) to Most Challenging (3)	What Makes This Instruction Challenging for You?
Be quick to listen		
Be slow to speak		
Be slow to anger		

What are three ways your friendships and relationships would change if you practiced James' instructions?

5. **Read James 1:21.**

What role does humility play in your receiving and responding to God's Word?

How have you experienced God's Word transforming you?

> Those who guard their lips preserve their lives, but those who speak rashly will come to ruin.
> Proverbs 13:3

What morally questionable influences from the world have you allowed into your life?

What steps do you need to take to remove them?

Reflection

As you reflect on your personal study of **James 1:1–21**, what are the words the Holy Spirit has been highlighting to you through this time? Write or draw them in the space below.

Preparation

Read James 1:22–27 to prepare for the next session.

☑ Summarize this passage in two to three sentences.

☑ What do you connect with most in this passage about hearing and doing?

☑ What challenges you most in this passage about hearing and doing?

GROUP STUDY

YOUR RESPONSE TO GOD'S WORD MATTERS

Opening Group Activity

Create a Word Cloud

What you'll need:

☑ A sheet of paper for each participant

☑ Colored pencils or pens for participants to share

1. A word cloud is a collection of words whereby the larger and bigger words have more emphasis or importance. Invite participants to draw a word cloud of what sparks procrastination in their lives. Some suggested words: perfectionism, fear of failure, busyness, distractions, disorganization, stress, lack of motivation, insecurity, anxiety, disinterest, difficulty.

2. Invite participants to share their drawings and discuss the following questions:

 ● What drives you to put off doing what you know you should do?

 ● What has helped you overcome tendencies for procrastination?

 ● Where are you tempted to procrastinate in your relationship with God?

Session Two Video

(19 MINUTES)

Leader, stream the video or play the DVD.

As you watch, take notes while thinking through:

What caught your attention?

What surprised you?

What made you reflect?

Video Notes

- Story of neighbor's weeds

- *Shema*—attentiveness, taking heed, responding with action

- Magnification mirror

- Widows and orphans

- Believe this is for me

- Act fast on your best intentions

SCRIPTURE covered in this teaching session: **James 1:22–27**

Group Discussion Questions
(30–45 MINUTES)

Leader, read each numbered prompt and question to the group and select volunteers for Scripture reading.

1. **Margaret teaches:**

 > **❝** I'll study a passage on prayer, and then not bother to talk to God all day. I'll watch a teaching on God's kindness, and then rudely hang up on the telemarketer just doing their job. I'll go to church, listen to a sermon on grace and patience, then pull out of the church parking lot, and whisper bitter somethings toward the driver who cut me off. I struggle to be a hearer and doer of God's Word. I think, if we're honest, we all do. **❞**

 In what ways can you relate to Margaret's struggle to act in response to God's Word?

 What's the greatest hurdle for you to overcome in order to hear *and* respond to God's Word?

What helps you experience God's Word in such a way that it actually transforms your attitudes, actions, or relationships?

2. **Invite two volunteers to read James 1:22–25 and Matthew 7:24–27.**

What parallels do you see between James' call to hear and obey and Jesus' call to hear and obey in the Sermon on the Mount?

What percentage of the time while listening to a sermon or message do you think, *That's for so-and-so?*

What justifications do you sometimes allow yourself for assigning the task of doing what God instructs to someone else? Examples: *I'm not qualified, I'm too busy, that's too hard, someone else would be better, surely Jesus didn't mean that literally, that doesn't really apply to today's world, etc.*

How does assigning the message or lesson to someone else short-circuit the work God wants to do in and through your life?

3. **Ask two volunteers to read James 1:27 and Isaiah 1:17.**

Jesus made a beeline toward people the religious leaders stayed away from. Who are the people or groups Jesus would make a beeline toward today?

How are you including, serving, and loving these people or groups now?

Who are the orphans and widows in your life and what are you doing to support them emotionally, financially, and relationally?

4. Margaret teaches:

> ❝ One of the things that makes me a hearer of God's Word and not a doer is that I have the best of intentions. I mean, when it comes to *thinking about* doing something kind or compassionate for others, I feel like I am world class! But when it comes to actually doing them, I'm *womp, womp.* The longer we wait to do what the Word of God prompts us to do, the less likely we are to do it. ❞

How often do you intend to do something kind or compassionate but not follow through?

Reflecting on your word cloud from the opening activity, what word best describes why you don't respond to God's Word in obedience?

What do you think would happen if you shortened that time gap and acted fast?

What changes in your schedule do you need to make to create more margin for obeying what God calls you to?

What's something you've been intending to do but delayed?

5. When it comes to being a hearer and doer of God's Word, Margaret describes the power of taking the time to pray, "God, what are you calling me to do today?"

Take three to five minutes now to sit in silence or play soft music in the background. Invite each person to prayerfully consider what God is calling them to do. Each person should pay attention to any people, faces, situations, or circumstances that come to mind.

Go around the group answering a selection of the following questions:

What, if anything, came to mind as you prayed?

What's hindering you from acting on that leading?

What can you do to act fast on what came to mind?

What changes do you need to make in your life to become a hearer and doer of Jesus' teaching?

 Hearing and doing are a match made in heaven.

Close in Prayer

Consider the following prompts as you pray together for:

☑ Readiness to truly hear and act on God's Word

☑ Quicker responses to God's nudges

☑ Courage to serve and love the outcast and marginalized

Preparation

To prepare for the next group session (Session 3):

☑ **Read James 2:1–13.**

☑ Tackle the three days of the Session Two Personal Study.

☑ Memorize this week's passage using the Scripture memory coloring page. As a bonus, look up the Scripture memory passage in different translations and take note of the variations.

☑ If you've agreed to bring something for the next session's Opening Group Activity, get it ready. See page 60 for the list of needed items.

Do not merely
listen to the
word, and
so deceive
yourselves.
Do what it says.

James 1:22

PERSONAL STUDY TIME

SESSION

2

YOUR RESPONSE TO GOD'S WORD MATTERS

DAY 1
James 1:22–25

Those living in antiquity didn't have access to modern lighted mirrors with magnification. Rather, they were made of polished bronze which provided a dull, contorted reflection. A user couldn't flash a once-over and know what they looked like. These ancient mirrors required taking time, studying the face, and looking for grime or dirt that needed to be washed away. James uses this imagery to teach us that some people pay attention to the reflection, but then walk away without doing anything about what they saw.

1. **Read James 1:22.**

 On the continuum below, mark which best describes you as a hearer or a doer of God's instruction.

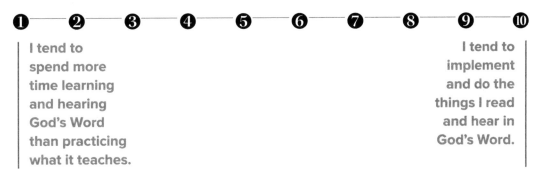

 ❶——❷——❸——❹——❺——❻——❼——❽——❾——❿

 I tend to spend more time learning and hearing God's Word than practicing what it teaches.

 I tend to implement and do the things I read and hear in God's Word.

2. **What happens when you hear Jesus' teaching but don't act on it?**

3. What happens when you hear Jesus' teaching and *do* act on it?

4. **Read Luke 11:28 and John 13:17.**

 Where have you tricked yourself into believing that hearing God's Word is the same as doing?

5. Describe a time when you responded quickly to what Jesus called you to do. How did that impact your faith, relationships, or life?

DAY 2
James 1:23–25

In antiquity, mirrors were expensive, and often only the wealthy could afford them. Most people had never seen themselves and were dependent on how others saw and described them. To have the opportunity to look into a mirror was a privileged opportunity.

1. **Read James 1:23–24.**

 What are three ways you can avoid forgetting what God's Word says about you and what you need to do?

When James challenges us to "look intently into the perfect law that gives freedom" (v. 25), he challenges us to look at the Old Testament law and prophecies as fulfilled in Christ. Unlike a law that binds or weighs down, the perfect law brings freedom. This noteworthy characteristic of the law is mentioned again in James 2:12.

2. **Read James 1:25. How have you experienced God's blessing and freedom through listening to and doing what Jesus instructs?**

3. Read John 14:21–24. What does Jesus say about love and obedience?

4. In what areas has your knowledge of God's Word outgrown your obedience to it?

5. In the space below, write a prayer asking God to help you become fast to obey.

DAY 3
James 1:26–27

James concludes his teaching on obedience to God's Word by challenging us to consider where hypocrisy may have slipped into our lives. One of the ways we can identify that our religion is shallow or pretend is by examining the words we speak. Another way is by looking at those on the margins of society—how we treat those who can do nothing for us.

1. **Read James 1:26–27.**

 How does James distinguish between worthless and pure religion?

Characteristics of Worthless Religion	Characteristics of Pure Religion

2. Describe a time you encountered someone who, because of their gossip, slander, cruelty, or the judgmental nature of their words, undermined their proclamation of faith.

> A father
> to the
> fatherless, a
> defender
> of widows,
> is God in
> his holy
> dwelling.
> Psalm 68:5

Describe a time you disqualified yourself as a trusted friend, co-worker, or Christian to others because of your gossip, slander, cruelty, or the judgmental nature of your words.

How does James' instruction to be quick to listen, slow to speak, and slow to be angry (1:19) help us avoid worthless religion?

Throughout the Old Testament, God commands the protection and care of widows and orphans.

3. Look up the following passages that demonstrate God's concern for and call to action regarding the widows, orphans, and marginalized. Fill in the chart below.

Scripture	What's Mentioned and Instructed
Deuteronomy 10:17–18	
Deuteronomy 14:28–29	
Deuteronomy 24:19–21	
Isaiah 1:17	
Zechariah 7:9–10	

Which of these passages stands out to you most? Why?

4. How are you practically reaching out to the parentless and widows in your life?

In our modern world, who, like the parentless and widow, are often overlooked, financially challenged, and in need of generous support and love? (Examples: single moms, chronically ill, etc.)

5. What are three specific and practical steps you can take this week to be a doer and not just a hearer of **James 1:19–27**?

☑ ..
..

☑ ..
..

☑ ..
..

Reflection

As you reflect on your personal study of **James 1:22–27,** what are the words the Holy Spirit has been highlighting to you through this time? Write or draw them in the space below.

Preparation

Read James 2:1–13 to prepare for the next session.

☑ Summarize what happens in this passage in two to three sentences.

☑ What do you connect with most in this passage?

☑ What challenges you most in this passage?

GROUP STUDY

HOW YOU SEE OTHERS MATTERS

Opening Group Activity

(10–15 MINUTES)

The Price Is Wrapped Game

What you'll need:

☑ Five (or more) gift-wrapped items where the outside wrapping may or may not represent the value of what's inside. Find out from the person who brings each item what the real value is. Keep track of this as the leader.

☑ A sticky note that provides a number to each item—1 to 5 (or more)

☑ Pens and note paper for participants to guess the value of each wrapped item

☑ A few fun prizes such as a snack or gold sticker

1. Hand out pens and note paper to participants. Invite them to write down numbers 1 to 5 (or however many wrapped items).

2. Ask participants to guess each wrapped item's value based on the look of the wrapping and write it down next to its number. Have them guess what they think is inside, too, and write that down.

3. After everyone completes their guesses, reveal the actual contents and their values.

4. Award fun prizes to the people who were closest to and furthest from the actual values.

Discuss the following questions:

- Which item's wrapping best represented what was inside?

- Which item's wrapping was most misleading from what was inside?

- Describe a time when you made a snap judgment about someone or something and she/he/it turned out to be so much better than you expected.

Session Three Video

(25 MINUTES)

Leader, stream the video or play the DVD.

As you watch, take notes while thinking through:

What caught your attention?

What surprised you?

What made you reflect?

Video Notes

☑ Favoritism is the outward expression of an inward judgment

☑ Story of Margaret living in Maggie Valley

☑ Person with golden fingers and the man in camo

☑ Favoritism leaches love out of our lives

☑ Story of a missionary and her coat

☑ Becoming more merciful

SCRIPTURE covered in this teaching session: James 2:1–13

Group Discussion Questions
(30–45 MINUTES)

Leader, read each numbered prompt and question to the group and select volunteers for Scripture reading.

1. Describe a time when you experienced or encountered favoritism (or a lack thereof) in each of the following:

 ☑ A group of friends

 ☑ A workplace

 ☑ Your family

 ☑ Among believers

 What did these experiences teach you about the harm that comes from favoritism or partiality?

How did these experiences make you more compassionate toward those who are overlooked, ignored, or marginalized?

2. Margaret creates an imaginative retelling of James' illustration using the man with gold fingers and the man in camo, then asks:

> "" Are you tempted to make a beeline toward the influencer? Fawn over him? Ask him if he needs anything (for hospitality's sake) or if you can do anything to make his visit more comfortable? Maybe slip in a selfie, along with that fabulous nonprofit or business idea you've been working on and praying about for years? Are you tempted to assume the guy in camo needs his own space so he's not a distraction to the whole group? Maybe you invite him to sit with you in the very back, or hope someone else takes responsibility, so you don't have to deal with him. ""

Which of these (or other) responses toward the man with gold fingers are you most prone to?

Which of these (or other) responses toward the man in camo are you most prone to?

To whom have you shown favor because you knew you could profit from it?

Who has shown you favor because the person knew she/he could profit from it? How did this make you feel?

Why do you think God doesn't want us to treat each other this way?

In what area of your life do you feel the biggest temptation to show favoritism?

3. **Select volunteers to read James 2:12–13; Matthew 5:7; and Matthew 7:1–2.**

Discuss a selection of the following:

What parallels do you see between James' instruction and Jesus' Sermon on the Mount?

Both judgment and mercy are boomerangs that, when extended, come right back at us.

Describe a time when someone showed you mercy instead of judgment. How did that experience impact and shape you?

Describe a time when you showed someone mercy instead of judgment. How did that experience impact and shape you?

4. Margaret gave three practical actions to take to become Mercy People. The first is:

Ruthlessly Eliminate What Makes You More Judgmental

Go around the group answering a selection of the following questions:

What are you currently subscribed to or watching in entertainment, news, or social media that makes you less kind, less gracious, and less merciful?

What in your life is causing you to reduce people to issues rather than seeing them as flesh and blood, made in God's image?

What are you giving your time and attention to that's making you more judgmental?

How will you ruthlessly eliminate these sources of judgmentalism from your life?

5. Margaret gave two more practical actions to become Mercy People:

<div align="center">

Surround Yourself with Mercy People

and

Prayerfully Ask God, "Who Is Your Favorite for Me Today?"

</div>

Go around the group answering a selection of the following questions:

Who are some of the biggest Mercy People in your life who can help you give the benefit of the doubt, love people who are wildly different, and have a keen eye to see and serve those who are marginalized?

How can you deepen your relationships with these Mercy People?

Take a few moments to prayerfully consider who God is calling you to love and serve, and act on it.

God's mercy isn't just meant to flow to us, it's meant to flow through us.

Close in Prayer

Consider the following prompts as you pray together for:

- ☑ Ability to see everyone through the lens of Christ
- ☑ Courage to eliminate that which makes us judgmental
- ☑ Daily opportunities to become more merciful

Preparation

To prepare for the next group session (Session 4):

- ☑ **Read James 3:1–12.**
- ☑ Tackle the three days of the Session Three Personal Study.
- ☑ Memorize this week's passage using the Scripture memory coloring page. As a bonus, look up the Scripture memory passage in different translations and take note of the variations.
- ☑ If you've agreed to bring something for the next session's Opening Group Activity, get it ready. See page 86 for the list of needed items.

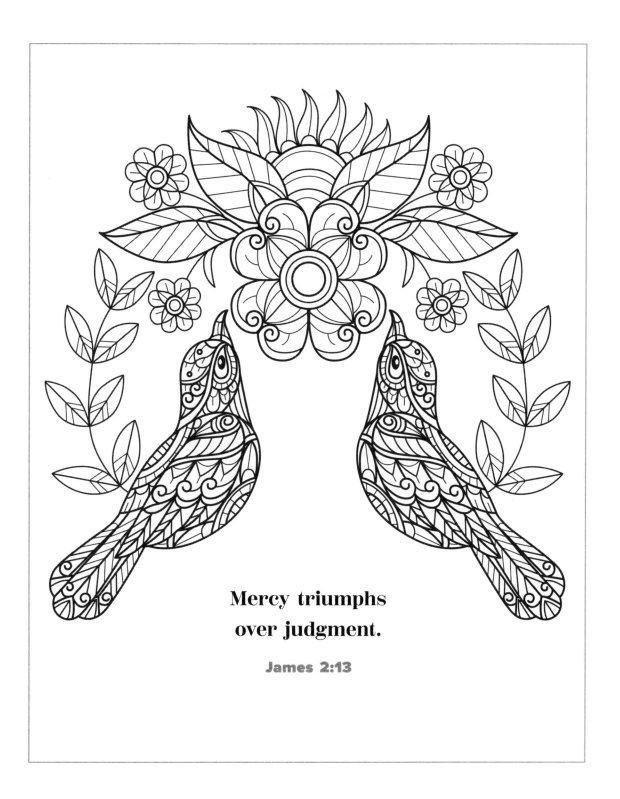

Mercy triumphs over judgment.

James 2:13

PERSONAL STUDY TIME

SESSION
3

HOW YOU SEE OTHERS MATTERS

DAY 1
James 2:1–4

In James 1:1, James identified himself as "a servant of God and of the Lord Jesus Christ." Now he addresses Jesus, his brother, overflowing with love and adoration, as "our glorious Lord Jesus Christ." Throughout this letter he continues to reveal respect, honor, and adoration for his brother.

Now when it comes to showing favoritism among gatherings of believers, James doesn't mince words. He has a zero-tolerance policy for favoritism. He knows that favoritism in all its forms impedes believers from being doers of God's Word instead of just listeners. James illustrates this by describing a meeting in which two distinct people walk through the door.

1. **Read James 2:1–4.**

 What specific details are given about each person who comes to the meeting?

 Person #1:

 Person #2:

 What do you think James is trying to communicate through these sharp contrasts?

2. When have you seen partiality demonstrated in your faith community? What happened?

What are some of the unintended consequences of favoritism in a faith community?

The Greek word for "favoritism" suggests making judgments about others based on "face" or outward appearances.

3. What are you doing to be part of the solution?

4. Who are some people who might make you feel uncomfortable if they came to your community of faith?

What does your response reveal about your personal biases or discrimination?

5. What do the following passages reveal about showing partiality? Fill in the chart below.

Scripture	Details about Showing Partiality
Exodus 23:1–3	
Leviticus 19:15	
Deuteronomy 10:14–19	
1 Timothy 5:19–21	

Ask the Holy Spirit to reveal any people you've overlooked or ignored or hesitated to engage. In the space below, next to each person's name, write a plan for how you'll reach out and demonstrate compassion and kindness.

Name	How You'll Show Compassion and Kindness

In the space below, write a prayer asking God to give you his heart and perspective toward others.

DAY 2
James 2:5–13

Throughout his letter, James has been referring to his readers as "brothers and sisters" (1:2; 2:1). Now he addresses them as "my dear brothers and sisters" (2:5). James reminds his readers that he deeply cares for them even while delivering some hard truths based on Jesus' Sermon on the Mount and asking some challenging questions.

These questions highlight the oppression exercised by those with power and wealth. James uses these questions to remind readers that when you try to be a player among the players, don't be surprised if you get played.

1. **Read James 2:5–7.**

 What is the great irony about the people the believers are showing favor to?

2. **How does God see those who are poor according to v. 5?**

 What would help you see others through this perspective?

Drawing on the laws from the Torah (the first five books of the Old Testament), James argues that though we're tempted to think that showing partiality isn't a big deal, it's just as much a transgression as breaking other laws.

3. Read James 2:8–11.

What does showing favoritism, even if it's subtle, reveal about the state of your own heart?

Favoritism is an outward expression of an inward judgment. Such a partiality creates barriers to serving and loving others. If our energy and focus are toward those who have more or can offer more, then we're less likely to see or even notice the people God is calling us to know, love, serve, and show mercy to. If our favoritism is left unchecked, we may even develop a rationale for why we don't love those around us: we don't have time or energy, or that person is rough around the edges, or that person disagrees politically, or that person is socially awkward. Favoritism is a fast track to becoming hearers of the Word and not doers.

James challenges us to look at the perfect law of liberty for the second time in his letter (the first is in James 1:25). The Jewish people were bound to follow 613 laws, an impossible task. But through the fulfillment of the law through Jesus' death and resurrection, believers are no longer saved by keeping a perfect record through the laws. Jesus unleashes forgiveness through a new covenant based on grace and mercy.

4. **Read James 2:12–13 and Matthew 7:1–2.**

 How have you experienced mercy triumphing over judgment?

 What do the following passages reveal about God's mercy toward you?

 Ephesians 2:4–5

 Titus 3:5

 Hebrews 4:15–16

 1 Peter 1:3

 Reflecting on the mercy you've been given, what's the greatest hindrance to you lavishing mercy on others?

Mercy is not a pie-in-the-sky idea. Mercy is demonstrated through action.

5. Take a few moments to prayerfully consider the people in your life toward whom you've been resisting showing mercy. Write their names in the space below. Then write down one action you can take to show mercy toward each person.

Name	Action You Can Take to Show Mercy This Week

DAY 3

James 2:14–26

Some try to separate faith from works and even go so far as to pit them against each other. But faith and works are a match made in heaven. James celebrates faith and the actions we take in response to it. After all, if we are in relationship with Jesus, then we are meant to be transformed from the inside out by the power of the Holy Spirit to do all the things that Jesus says.

1. **Read James 2:14–19.**

 How do you demonstrate your faith in action?

 When have you claimed to have faith but not backed it up with corresponding action?

2. **What do you use to evaluate whether your actions align with your faith?**

James turns to Abraham as an example of faith in action. Abraham is considered righteous for offering up his son, Isaac. Abraham believed that God would provide a way, even if it meant sacrificing his beloved son. His willingness to obey God's command demonstrated his complete trust in God and his devotion to follow His will, even if it seemed counterintuitive. This act of faith shows that Abraham's righteousness was not merely a matter of words, but a deep-seated conviction that drove him to action.

3. **Read James 2:20–24.**

What have you sacrificed in obedience to God?

How did faith and action work together in your sacrifice?

What was the fruit or result of your obedience?

Next, James draws on the example of Rahab. She was a Canaanite and a prostitute who lived in a culture that was hostile to the God of Israel. Yet her faith was not merely a matter of words or beliefs, but was evidenced by her willingness to risk her life to protect the Israelite spies.

4. **Read James 2:25–26 and Joshua 2:1–21.**

 How can you cultivate a heart of faith and courage like Rahab's?

 What steps can you take to grow in your trust in God?

5. **What does it mean to have a dead faith (James 2:26)?**

How can you guard against falling into this category?

What role does the Holy Spirit play in producing a living faith within you?

How can you cultivate a deeper reliance on the Holy Spirit in your faith journey?

Reflection

As you reflect on your personal study of **James 2,** what are the words the Holy Spirit has been highlighting to you through this time? Write or draw them in the space below.

Preparation

Read James 3:1–12 to prepare for the next session.

☑ Summarize what happens in this passage in two to three sentences.

☑ What do you connect with most in this passage about the words we speak?

☑ What challenges you most in this passage about words we speak?

GROUP STUDY

SESSION
4

WHAT YOU SAY MATTERS

Opening Group Activity

(10–15 MINUTES)

What I See in You!

What you'll need:

☑ 3x5 cards

☑ Pen for each participant

1. Divide participants into groups of 4–6.

2. Give each person enough cards to have one for each person in their group.

3. Ask participants to write down what they really appreciate about each person in their group. Be specific. Write a characteristic, quality, or gift you recognize in each person.

4. Invite participants to share aloud what they wrote about each person.

5. Discuss the following questions:

 • How did the kind words spoken about you make you feel?

 • Which of the statements surprised you most?

 • Which do you enjoy more: saying kind words to others or receiving them? Explain.

Session Four Video

(23 MINUTES)

Leader, stream the video or play the DVD.

As you watch, take notes while thinking through:

What caught your attention?

What surprised you?

What made you reflect?

Video Notes

☑ Story of the stranger with four powerful words

☑ Rabbi means "great one"

☑ Story of wildfire

☑ "God, you made junk"

☑ Our words are a litmus test for our hearts

☑ We have the best assignment ever

SCRIPTURE covered in this teaching session:
James 3:1–12

Group Discussion Questions
(30–45 MINUTES)

Leader, read each numbered prompt and question to the group and select volunteers for Scripture reading.

1. Margaret teaches:

 > 'Stay in the game.' Those words came from a stranger. Those syllables breathed strength and life into these weary bones. They reminded me that the work God began, he would bring about to completion. They were a call to obedience, no matter the cost. Those four words buoyed my soul, not just that day but even now years later.

 Describe a time when someone spoke words that buoyed your soul, gave you strength, or helped you keep going. What words did they use?

 Describe a time when someone crushed you with their words. How did you find healing?

During your average week, how often does someone speak words that really encourage you?

During your average week, how often do you go out of your way to speak words that really encourage someone else?

What are some of the characteristics of life-giving words?

2. **Select a few volunteers to read James 1:26; James 3:3–8; Matthew 12:34–37; Matthew 15:18–19; and Luke 6:45.**

What does James teach about the way we use our words?

What does Jesus teach about the way we use our words?

Why are James and Jesus so concerned with the words we use? What do the words we speak reveal about us?

Which of the images in James 3:3–8 stands out to you most? Why?

3. Discuss a selection of the following questions:

When was the last time your words got you into trouble? How did you go back and try to heal the situation?

What helpful tactics have you found to heal a relationship after you've said something you regretted?

Where do you tend to speak more careless words—face to face, on the phone, through email or text, or through online comments or posts?

How does the setting you're in influence the words you speak?

Do you tend to be someone who initiates unkind words or piggybacks on others' unkind words? Explain.

What tactics have helped you redirect unwholesome conversations toward more life-giving topics?

4. Margaret teaches:

> **"The ruthless words we use with others never compare with the barbarous things we say to ourselves. Whatever unkind thing you've said about someone else, you've already said to yourself—dozens, if not hundreds, if not thousands, of times. It's really hard to fulfill Jesus' command to love your neighbor as yourself if you don't even like yourself. If you struggle with your internal dialogue, healing and freedom are possible."**

On a scale of 1 to 10, how much do you struggle with your internal dialogue?

Where does this harsh inner critic come from?

What have you found most helpful in hushing this harsh inner critic?

What role does God's Word play in hushing these untruths?

How does showing compassion toward yourself help you show compassion toward others?

5. Margaret gave three tactics for becoming people who speak with the plans, purposes, and power of God:

<div align="center">

Align Yourself with God's Lovingkindness

and

Choose Reflection Over Reaction

and

Look for Every Opportunity to Speak Life

</div>

Go around the group answering a selection of the following questions:

Which of these tactics is easiest for you to remember and implement? Which is the most challenging?

What tactics would you add to this list?

What's stopping you from implementing these tactics?

As followers of Jesus, we are called to speak strength into weakness, hope into despair, life into death.

Close in Prayer

Consider the following prompts as you pray together for:

- Wisdom and maturity in words, tone, and interactions
- Strength to be quick to listen, and slow to speak and anger
- Opportunities to speak life everywhere you go

Preparation

To prepare for the next group session (Session 5):

- **Read James 5:1–6.**
- Tackle the three days of the Session Four Personal Study.
- Memorize this week's passage using the Scripture memory coloring page. As a bonus, look up the Scripture memory passage in different translations and take note of the variations.
- Ask members to bring something for the next session's Opening Group Activity—it's a fun one! See page 114 for the list of needed items.

Anyone who is never at fault in what they say is perfect, able to keep their whole body in check.

James 3:2

PERSONAL STUDY TIME

WHAT YOU SAY MATTERS

DAY 1
James 3:1–12

In the opening chapter, James said that true religion, the kind that's pure and faultless, is to look after widows and orphans and keep from being polluted by the world (James 1:27). He compared this true religion with worthless religion, which is marked by an uncontrolled tongue. Worthless religion creates a self-deception whereby people can hear God's Word but not do what it says.

James now revisits the importance of controlling our words in more depth. The words we use, whether or not we have the word "teacher" in our title or job description, have power to bring life or destruction.

1. **Read James 3:1–2. Though you may (or may not) have an official title of "teacher," who are the people you guide, mentor, encourage, and influence?**

 Why is it important to believe this passage is for you and not assign the task to someone else?

> Those who guard their mouths and their tongues keep themselves from calamity. Proverbs 21:23

2. Many people throughout the Bible struggle with controlling their tongues. What do each of the following passages reveal about the person's words or lips? Look up the Scriptures and fill in the chart below.

Name	Passage	What It Reveals about the Person's Words or Lips
Job	Job 42:3	
Moses	Psalm 106:32–33	
Isaiah	Isaiah 6:5	
Peter	Matthew 16:22–23	

3. What do the following passages reveal about the words we speak? Circle the one that is most meaningful to you. Underline the one that is most challenging to you.

Proverbs 11:9:

Proverbs 16:24:

Proverbs 18:21:

Ephesians 4:29:

4. When it comes to your words, which of the following are you most prone to? Circle all that apply.

Cynicism	Sarcasm	Shaming
Gaslighting	Slander	Off-color jokes
Scapegoating	Condescending remarks	Belittling
Gossip	Spreading rumors	Criticism
Backbiting	Suspicion	Other _____

Was there someone in your life who intentionally or unintentionally taught you to respond in this way? If so, describe how you learned the behavior.

5. **Read James 3:3–12.** How does a divided tongue reveal a disconnection with real faith?

What is the biggest hurdle you face when it comes to controlling your tongue?

What are three practical steps you can take this week to bring your tongue, and more importantly, your heart, into alignment with God?

Who are three people you can speak life into this week? What words do they most need to hear?

Name	Words They Need to Hear

DAY 2
James 3:13–18

James returns to the teaching that wisdom shows itself through godly living. Just as the book of Proverbs encourages us to pursue wisdom for the peace and good life it brings (Proverbs 3:13–18), James encourages us to do the same.

1. **Read James 3:13.**

 What are the characteristics of someone who is wise and understanding?

2. **Read Colossians 3:12–17.**

 How are we to be transformed from the inside out?

 What practical wisdom can you pull from this passage about interacting with others and leading a good life?

3. Read James 3:14–17.

What are the differences between earthly and heavenly wisdom? Fill in the space below:

Earthly Wisdom	Heavenly Wisdom

Who are you envying right now?

How can you become more thankful for what you have rather than focusing on what you don't have?

Write a prayer of gratitude for what you have in the space below.

4. **Read Galatians 5:22–23.**

 Make a list of the fruit of the spirit. Then circle the ones that are also listed in James 3:17.

 ☑ _____

 ☑ _____

 ☑ _____

 ☑ _____

 ☑ _____

 ☑ _____

 ☑ _____

 ☑ _____

 ☑ _____

5. **How is James calling you to grow into the fullness of Christ?**

6. **Read James 3:18 and Matthew 5:9.**

What are the blessings of being a peacemaker?

Spend a few moments asking the Holy Spirit to reveal people you need to make peace with. Write their names in the space below.

☑ _____

☑ _____

☑ _____

Next, develop a plan to do something kind to bless each person. This could be as simple as sending an encouraging text, writing an email of apology, sending an electronic gift card, popping a present in the mail, or meeting together in person.

If possible, take the next fifteen minutes or so to reach out and do the kind actions you listed above. If the actions you listed call for an in-person interaction, perhaps reach out to the person and schedule a time when you can meet up.

DAY 3
James 4

James continues to challenge the way we use our words and interact with others. He pushes us to look at the deeper issues within our hearts. After distinguishing between earthly and heavenly wisdom, James challenges us to look for areas in our lives where we're responding from the wrong type of wisdom.

James addresses conflict among believers. While some scholars note that James was addressing physical battles as the Jewish zealot movement was becoming more aggressive, he also addresses the conflict created through our words.

1. **Read James 4:1–6.**

 What is the source of fighting and quarreling among the believers?

> In James 4:1, the Greek word for "quarrels" is *machai*, and it can be translated as "strife or battles of any kind."

In James 4:3, the word "pleasures" comes from the Greek word *hedonon*, which gives us the word "hedonism" and describes an attitude of sinful self-indulgence. James goes on to draw from Old Testament imagery that describes God's relationship with his people in terms of a marriage covenant (Isaiah 54:1–6; Jeremiah 3:20).

What are some signs of friendship with the world?

What are some signs of friendship with God?

What is pulling you away from friendship with God right now?

What steps do you need to take to eliminate those things that tug your heart away from God?

James offers a powerful prescription for breaking up with the world and giving oneself wholly and fully to God: an outward change in behavior (washing one's hands) and an inward change (purifying one's heart).

2. **Read James 4:7–10; Psalm 24:3–4; and Matthew 5:4, 8.**

 What does James instruct us to do in order to return wholeheartedly to God?

 Which of these is most challenging for you?

Returning to the theme found in James 3:1–12, James again brings up the issue of the words we use and their impact. He also addresses the booming commerce of the time which has left some people feeling self-secure and self-sufficient in their wealth and work.

3. **Read James 4:11–16.**

 What challenges does James issue regarding the words we speak?

What are the judgments hidden in your heart that your words reveal?

4. **Read James 4:17 and Proverbs 3:27–28.**

 What's one good thing you know in your spirit you should do but have left undone?

 What is the biggest hurdle to finally getting it done?

5. Take five to ten minutes right now to start doing that thing you need to do. Pull out your schedule and map out a plan and completion date.

 How does it feel to be a hearer *and* doer of what God is calling you to?

Reflection

As you reflect on your personal study of **James 3–4,** what are the words the Holy Spirit has been highlighting to you through this time? Write or draw them in the space below.

Preparation

Read James 5:1–6 to prepare for the next session.

☑ Summarize what happens in this passage in two to three sentences.

☑ What do you connect with most in this passage?

☑ What challenges you most in this passage?

GROUP STUDY

HOW YOU LIVE MATTERS

Opening Group Activity

(10–15 MINUTES)

Let's Celebrate

What you'll need:

- Each person to bring food to share
- Party balloons or fun decorations

1. Decorate the room with balloons, streamers, wildflowers, and anything else you can find to create a festive atmosphere.

2. Enjoy laughing, talking, sharing, and catching up as you eat together.

3. Take a photo of your group and send it to hello@margaretfeinberg.com so Margaret can see your smiling faces and celebrate with you.

4. Discuss the following questions:

- What have you enjoyed most about diving into the book of James?

- What's one question or topic from the personal study time or group discussion that really challenged you or stuck with you?

- What's one thing you've done to become a doer of God's Word and not just a hearer?

Session Five Video

(18 MINUTES)

Leader, stream the video or play the DVD.

As you watch, take notes while thinking through:

What caught your attention?

What surprised you?

What made you reflect?

Video Notes

- This is for me

- Wealthy withheld wages

- Story of scarfs

- It's not just *what* but *who* we are waiting for

- Don't take the bait

- Jesus invites us to follow him

SCRIPTURE covered in this teaching session:
James 5:1–6

Group Discussion Questions
(30–45 MINUTES)

Leader, read each numbered prompt and question to the group and select volunteers for Scripture reading.

1. Margaret teaches:

> "James challenges us to look at how we treat those we work with and alongside in everyday life. That includes the checkout clerk at the grocery store. The customer service agent on the other end of the phone. The doctor who's running an hour late. The church employee who is having a bad day.
>
> A common phrase in business is 'The customer is always right.' But if left unchecked, we can become 'customers' who are entitled, impatient, and unkind—sharing some of the same attitudes of the wealthy James describes."

On a scale of 1 to 10, how often do you read a passage of Scripture and think, *So-and-so needs to see or do this,* rather than think, *This is for me!*?

Why is it important to consider not just what you do with your resources but how you got them?

In what ways have you given into entitlement, impatience, or unkindness toward those who either work for you or work around you every day?

2. Margaret tells the story of her out-of-control scarf collection.

Have you ever started purchasing or saving some favorite item and the collection grew too large?

What steps did you take to decrease or stop consuming?

What have you owned that has corroded, rotted, or been destroyed by something like moths—physically or metaphorically?

What is one practical way you can make the most out of what you've been entrusted with?

3. Select a few volunteers to read James 5:1–6; Matthew 6:19; and Luke 12:16–21.

Discuss some of the following:

What parallels do you see between James' and Jesus' teachings?

Describe a time when you discovered that money and possessions couldn't protect you.

Why is it easier to look at other people as rich and wealthy rather than seeing ourselves that way (even if you live in one of the richest countries in the world)?

How are you leveraging what you've been entrusted with to help others in everyday interactions?

In a culture that cries, "More, more, more," what is your enough?

4. Discuss a selection of the following questions:

What are some of the stops you've put in place to slow impulse purchases and instant access?

Which have been most effective? Least effective?

Which stops do you still need to put in place starting today?

5. James has challenged us to consider five areas of our lives that really matter: how we respond to hardship and trials; what we do with what we hear; how we see others; what we say to others; and how we live. Which of these areas or teaching sessions has most challenged you to grow?

What's your biggest takeaway from this study?

How may the Holy Spirit be empowering you to live differently because of this discovery?

 You're not just the object of God's affection, you're an agent of God's affection.

Close in Prayer

Consider the following prompts as you pray together for:

☑ Grace to demonstrate kindness and justice everywhere

☑ Humility and wisdom to steward well

☑ Wisdom on where to put stops on the instant and impulse

Conclusion

☑ Read James 5.

☑ Tackle the three days of the Session Five Personal Study.

☑ Memorize this week's passage using the Scripture memory coloring page. As a bonus, look up the Scripture memory passage in different translations and take note of the variations.

NOTE: If the group would like to meet for a sixth session, consider gathering to discuss a selection of the personal study time questions, and conclude by reading through the whole book of James together. And if you've enjoyed this study, check out *Revelation: Extravagant Hope* by Margaret Feinberg.

**You have condemned
and murdered the
innocent one, who was
not opposing you.**

James 5:6

PERSONAL STUDY TIME

SESSION
5

HOW YOU LIVE MATTERS

DAY 1

James 5:1–3

One of the ways we pursue friendship with the world instead of friendship with God is through our overemphasis on money. Greed has a way of eating away at our moral fabric until it gets in the way of loving others. If left unchecked, greed leads to the oppression of those who cannot defend themselves, compromises in integrity, and placing more trust in possessions than in God. All too often, wealth is not used to alleviate the suffering of those in need. In the first century, the markers of wealth were in clothes, gold and silver, and especially in land, which produced greater wealth through agriculture.

1. **Read James 5:1–3 and Luke 16:19–31.**

 How does James' teaching align with some of the ideas implicit in the story Jesus tells?

> An inheritance claimed too soon will not be blessed at the end.
> Proverbs 20:21

What are three ways your resources have made you callous, dismissive, or numb to the needs of others?

James has heard of some deeply selfish landowners who have refused to pay their hired harvesters for their work. He declares that those unpaid wages are crying out in oppression, as are the harvesters themselves, and God has heard these cries.

James is likely drawing from the story of Cain and Abel, when after Abel's death, his blood is described as crying out from the ground (Genesis 4:10). This imagery suggests that the landowners' selfishness is of very serious consequence to God.

2. Read James 5:4–6.

What are some practical ways in which your comfort comes at the expense of others? Examples may include child labor, low wages, environmental impact, etc.

3. Make a list of five types of workers you encounter each week. Examples may include a clerk at a grocery store or post office, a delivery worker, etc. Next to each type of worker, write down what you can do to show them greater appreciation, kindness, and generosity.

Type of Worker	Practical Way You'll Show Greater Appreciation and Generosity

Living in an unjust world means we will be people who unintentionally or intentionally contribute to injustice and oppression. Or we will be people who are on the receiving end of injustice and oppression. Or both. Most likely, if you live in the Western world today, then you both contribute to injustice and oppression and also are impacted by it.

There are injustices you may have faced because of where you were born. Who your parents were. The neighborhood you grew up in. The color of your skin. Your accent. Your genetics. Your neurodiversity. Your physical diversity. The quality of education afforded to you. And so much more.

James addresses how to respond as believers when we are on the receiving end of the world's injustice and oppression. Much like calling us to "consider it pure joy, my brother and sisters, whenever you face trials of many kinds" (James 1:2), James now calls us to patience and endurance in the midst of oppression. In James 5:7–11, the Greek word for patience, *makrothymeo*, appears four times, and the Greek word for perseverance, *hypomone*, appears twice.

4. **Read James 5:7–11.**

 What does James prescribe in this passage for those who are oppressed?

5. **In the midst of oppression and injustice, why is it so tempting to use our words to complain?**

How have you seen complaining eat away at patience, endurance, and the unity within a community?

What's one thing you've been complaining about that you need to instead take to God in prayer? Write a prayer regarding that one concern in the space below.

DAY 2
James 5:12–18

As James concludes his letter, he returns to the theme of wholesome speech, particularly as a response to suffering and hardship. He warns against following common oath-swearing practices in which the name of God or others is invoked. When we are people of integrity, our word can be trusted and a simple yes or no suffices.

1. **Compare Matthew 5:34–37 and James 5:12.**

 How does James' teaching echo Jesus' teaching?

Jesus	James
"But I tell you, do not swear an oath at all: either by heaven, for it is God's throne; or by the earth, for it is his footstool; or by Jerusalem, for it is the city of the Great King. And do not swear by your head, for you cannot make even one hair white or black. All you need to say is simply 'Yes' or 'No'; anything beyond this comes from the evil one." Matthew 5:34–37	"Above all, my brothers and sisters, do not swear—not by heaven or by earth or by anything else. All you need to say is a simple 'Yes' or 'No'. Otherwise you will be condemned." James 5:12

When have you been hurt or disappointed by someone making a promise or oath he or she couldn't keep?

When have you hurt or disappointed someone by making a promise or oath you couldn't keep?

James shifts from discussing oppressor and oppressed to address other forms of suffering, including sickness and sin. Once again, he challenges us to use our words well with each other and toward God.

2. **Read James 5:13–16.**

Respond by taking action through the questions below:

What's one area where there's trouble in your life? Write a prayer asking God for help and wisdom.

What's one area where you're happy and blessed? Write a lyric of thanks or word of praise.

Where are you hurting most right now in your body or mind? Who can you reach out to right now and ask for prayer? Write their name below, then do it before going on to the next question.

What's an area of sin you've been wrestling with? Think of one believer who "gets" you and with whom you can be vulnerable, someone to whom you can confess your struggle, who can pray for you to receive healing from God. Write their name below, then reach out to set up a time to connect before moving on to the next question.

First Kings 17–18 describes Elijah's vibrant prayer life as he prayed for a widow's son and for an end to the drought that had decimated the land. James uses this story to call us to petition God.

3. Read James 5:17–18.

When have you been in a desparate situation and God answered your prayers in the way you desired?

What holds you back from giving all your cares and concerns to God?

What healing, restoration, or truth do you need to receive to move beyond this self-created barrier in your prayer life?

The final words of James' letter are more than a final urging; they reveal what James has been doing throughout his letter. Since the opening verses, he's been identifying ways in which we're all tempted to wander from God—in the ways we respond to hardship, in the ways we fail to respond to God's Word, in the ways we show partiality toward others, in the ways we speak to each other, and in the ways we live everyday life.

Throughout this book, James has been drawing us back to God, gently and sometimes quite firmly showing us where we need to get back on track. Before we can encourage and serve those who have wandered, we must take a look at the path we ourselves are on and see where we've wandered—whether on purpose or unconsciously.

4. **Read James 5:19–20 and 2 Corinthians 5:18–21.**

 Reflecting on all you've read in James, where have you discovered you've wandered a bit and need to return wholly to Christ and all he's called you to?

5. Who in your life has been most helpful and loving in identifying when you've wandered from God in a specific area—and then welcomed you back home?

 What methods did that person use that you can implement in helping draw others back to Jesus, too?

DAY 3
Your Beautiful Word

Review your notes and responses throughout this study guide. Place a star by those that stand out to you. Then respond to the following questions:

1. **As you've been studying that *what you do matters* in James, what are three of the most important truths you've learned?**

How have those truths stretched you or encouraged you to follow Jesus more closely?

2. **After reviewing the five coloring pages, which Scripture stands out to you the most? Why?**

3. What's one practical application from studying the book of James that you've put into practice?

4. What's one practical application from the study that you would still like to put into practice?

5. How has the Holy Spirit prompted changes in your attitudes, actions, and behaviors as a result of studying the book of James?

What fruit has the Holy Spirit produced in your life as you've pursued becoming a hearer and doer of God's Word?

Reflection

As you reflect on your personal study of **James 5,** what are the words the Holy Spirit has been highlighting to you personally through this time? Write or draw them in the space below.

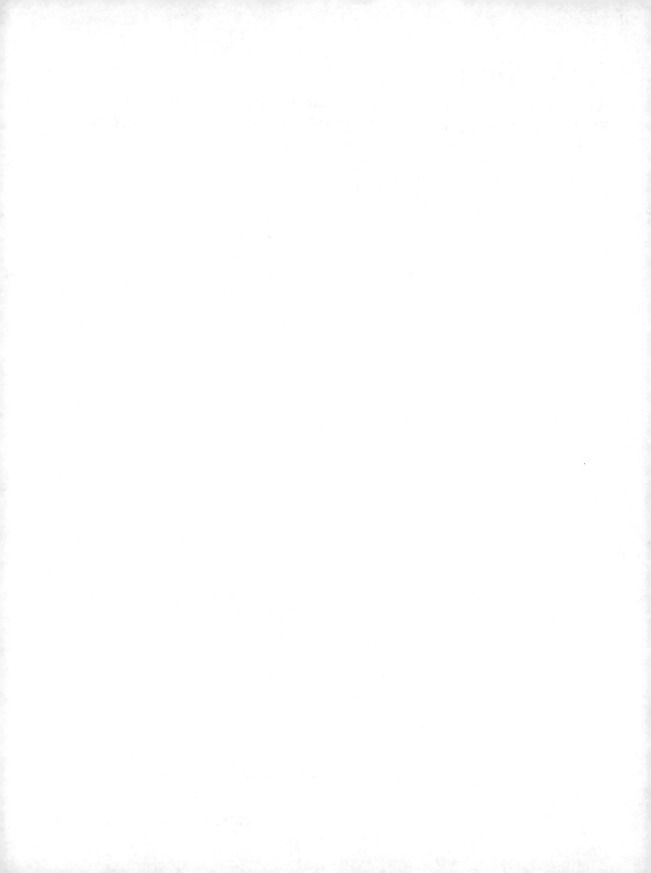

PARALLELS BETWEEN JAMES AND THE SERMON ON THE MOUNT

Adapted from *Introducing the New Testament* by Mark Allan Powell, 2018.

The Letter of James	Sermon on the Mount (Gospel of Matthew)
Consider it pure joy, my brothers and sisters, whenever you face trials of many kinds (1:2).	Blessed are you when people insult you, persecute you and falsely say all kinds of evil against you because of me. Rejoice and be glad, because great is your reward in heaven, for in the same way they persecuted the prophets who were before you (5:11–12).
Let perseverance finish its work so that you may be mature and complete, not lacking anything (1:4).	Be perfect, therefore, as your heavenly Father is perfect (5:48).
If any of you lacks wisdom, you should ask God, who gives generously to all without finding fault, and it will be given to you (1:5).	Ask and it will be given to you; seek and you will find; knock and the door will be opened to you. For everyone who asks receives; the one who seeks finds; and to the one who knocks, the door will be opened. Which of you, if your son asks for bread, will give him a stone? Or if he asks for a fish, will give him a snake? If you, then, though you are evil, know how to give good gifts to your children, how much more will your Father in heaven give good gifts to those who ask him (7:7–11)!

The Letter of James	Sermon on the Mount (Gospel of Matthew)
Believers in humble circumstances ought to take pride in their high position. But the rich should take pride in their humiliation—since they will pass away like a wild flower. For the sun rises with scorching heat and withers the plant; its blossom falls and its beauty is destroyed. In the same way, the rich will fade away even while they go about their business. Blessed is the one who perseveres under trial because, having stood the test, that person will receive the crown of life that the Lord has promised to those who love him (1:9–12).	"Blessed are the poor in spirit, for theirs is the kingdom of heaven. Blessed are those who mourn, for they will be comforted. Blessed are the meek, for they will inherit the earth" (5:3–5).
Every good and perfect gift is from above, coming down from the Father of the heavenly lights, who does not change like shifting shadows (1:17).	If you, then, though you are evil, know how to give good gifts to your children, how much more will your Father in heaven give good gifts to those who ask him (7:11)!
Because human anger does not produce the righteousness that God desires (1:20).	But I tell you that anyone who is angry with a brother or sister will be subject to judgment. Again, anyone who says to a brother or sister, "Raca," is answerable to the court. And anyone who says, "You fool!" will be in danger of the fire of hell (5:22).
Do not merely listen to the word, and so deceive yourselves. Do what it says (1:22).	"Therefore everyone who hears these words of mine and puts them into practice is like a wise man who built his house on the rock. The rain came down, the streams rose, and the winds blew and beat against that house; yet it did not fall, because it had its foundation on the rock. But everyone who hears these words of mine and does not put them into practice is like a foolish man who built his house on sand. The rain came down, the streams rose, and the winds blew and beat against that house, and it fell with a great crash" (7:24–27).

The Letter of James	Sermon on the Mount (Gospel of Matthew)
Listen, my dear brothers and sisters: Has not God chosen those who are poor in the eyes of the world to be rich in faith and to inherit the kingdom he promised those who love him (2:5)?	Blessed are the poor in spirit, for theirs is the kingdom of heaven (5:3).
For whoever keeps the whole law and yet stumbles at just one point is guilty of breaking all of it (2:10).	Therefore anyone who sets aside one of the least of these commands and teaches others accordingly will be called least in the kingdom of heaven, but whoever practices and teaches these commands will be called great in the kingdom of heaven. For I tell you that unless your righteousness surpasses that of the Pharisees and the teachers of the law, you will certainly not enter the kingdom of heaven (5:19–20).
Because judgment without mercy will be shown to anyone who has not been merciful. Mercy triumphs over judgment (2:13).	Blessed are the merciful, for they will be shown mercy (5:7).
Because judgment without mercy will be shown to anyone who has not been merciful. Mercy triumphs over judgment (2:13).	"Do not judge, or you too will be judged. For in the same way you judge others, you will be judged, and with the measure you use, it will be measured to you" (7:1–2).
What good is it, my brothers and sisters, if someone claims to have faith but has no deeds? Can such faith save them (2:14)?	Not everyone who says to me, "Lord, Lord," will enter the kingdom of heaven, but only the one who does the will of my Father who is in heaven (7:21).
My brothers and sisters, can a fig tree bear olives, or a grapevine bear figs? Neither can a salt spring produce fresh water (3:12).	By their fruit you will recognize them. Do people pick grapes from thornbushes, or figs from thistles (7:16)?

The Letter of James	Sermon on the Mount (Gospel of Matthew)
Peacemakers who sow in peace reap a harvest of righteousness (3:18).	Blessed are the peacemakers, for they will be called children of God (5:9).
You desire but do not have, so you kill. You covet but you cannot get what you want, so you quarrel and fight. You do not have because you do not ask God. When you ask, you do not receive, because you ask with wrong motives, that you may spend what you get on your pleasures (4:2–3).	Ask and it will be given to you; seek and you will find; knock and the door will be opened to you. For everyone who asks receives; the one who seeks finds; and to the one who knocks, the door will be opened (7:7–8).
You adulterous people, don't you know that friendship with the world means enmity against God? Therefore, anyone who chooses to be a friend of the world becomes an enemy of God (4:4).	No one can serve two masters. Either you will hate the one and love the other, or you will be devoted to the one and despise the other. You cannot serve both God and money (6:24).
Come near to God and he will come near to you. Wash your hands, you sinners, and purify your hearts, you double-minded (4:8).	Blessed are the pure in heart, for they will see God (5:8).
Grieve, mourn and wail. Change your laughter to mourning and your joy to gloom. Humble yourselves before the Lord, and he will lift you up (4:9–10).	Blessed are those who mourn, for they will be comforted (5:4).
Brothers and sisters, do not slander one another. Anyone who speaks against a brother or sister or judges them speaks against the law and judges it. When you judge the law, you are not keeping it, but sitting in judgment on it. There is only one Lawgiver and Judge, the one who is able to save and destroy. But you—who are you to judge your neighbor (4:11–12)?	Do not judge, or you too will be judged. For in the same way you judge others, you will be judged, and with the measure you use, it will be measured to you. Why do you look at the speck of sawdust in your brother's eye and pay no attention to the plank in your own eye? How can you say to your brother, 'Let me take the speck out of your eye,' when all the time there is a plank in your own eye? You hypocrite, first take the plank out of your own eye, and then you will see clearly to remove the speck from your brother's eye (7:1–5).

The Letter of James	Sermon on the Mount (Gospel of Matthew)
Now listen, you who say, "Today or tomorrow we will go to this or that city, spend a year there, carry on business and make money." Why, you do not even know what will happen tomorrow. What is your life? You are a mist that appears for a little while and then vanishes (4:13–14).	Therefore do not worry about tomorrow, for tomorrow will worry about itself. Each day has enough trouble of its own (6:34).
Your wealth has rotted, and moths have eaten your clothes. Your gold and silver are corroded. Their corrosion will testify against you and eat your flesh like fire. You have hoarded wealth in the last days (5:2–3).	Do not store up for yourselves treasures on earth, where moths and vermin destroy, and where thieves break in and steal (6:19).
Don't grumble against one another, brothers and sisters, or you will be judged. The Judge is standing at the door (5:9)!	Do not judge, or you too will be judged (7:1).
Brothers and sisters, as an example of patience in the face of suffering, take the prophets who spoke in the name of the Lord (5:10).	Rejoice and be glad, because great is your reward in heaven, for in the same way they persecuted the prophets who were before you (5:12).
Above all, my brothers and sisters, do not swear—not by heaven or by earth or by anything else. All you need to say is a simple "Yes" or "No." Otherwise you will be condemned (5:12).	But I tell you, do not swear an oath at all: either by heaven, for it is God's throne; or by the earth, for it is his footstool; or by Jerusalem, for it is the city of the Great King. And do not swear by your head, for you cannot make even one hair white or black. All you need to say is simply 'Yes' or 'No'; anything beyond this comes from the evil one (5:34–37).

SESSION BY SESSION OVERVIEWS

Session One: How You Respond to Hardship Matters

Scripture covered in this teaching session: **James 1:1–6, 17**

Scripture to study and read this week: **James 1**

Verse of the Week: Every good and perfect gift is from above, coming down from the Father of the heavenly lights, who does not change like shifting shadows. James 1:17

Discussion Question choices / notes:

Prayer requests

Session Two: Your Response to God's Word Matters

Scripture covered in this teaching session: **James 1:22–27**

Scripture to study and read this week: **James 1:22–2:13**

Verse of the Week: Do not merely listen to the word, and so deceive yourselves. Do what it says. James 1:22

Discussion Question choices / notes:

Prayer requests

Session Three: How You See Others Matters

Scripture covered in this teaching session: **James 2:1–13**

Scripture to read this week: **James 2:1–3:12**

Verse of the Week: Mercy triumphs over judgment. James 2:13

Discussion Question choices / notes:

Prayer requests

Session Four: What You Say Matters

Scripture covered in this teaching session: **James 3:1–12**

Scripture to read this week: **James 3:1–5:6**

Verse of the Week: Anyone who is never at fault in what they say is perfect, able to keep their whole body in check. James 3:2

Discussion Question choices / notes:

Prayer requests

Session Five: How You Live Matters

Scripture covered in this teaching session: **James 5:1–6**

Scripture to study and read this week: **James 5**

Verse of the Week: You have condemned and murdered the innocent one, who was not opposing you. James 5:6

Discussion Question choices / notes:

Prayer requests

SCRIPTURE MEMORY CARDS

SESSION 1

Every good and perfect gift is from above, coming down from the Father of the heavenly lights, who does not change like shifting shadows.

James 1:17

SESSION 2

Do not merely listen to the word, and so deceive yourselves. Do what it says.

James 1:22

SESSION 3

Mercy triumphs over judgment.

James 2:13

SCRIPTURE MEMORY CARDS

SESSION 4

Anyone who is never at fault in what they say is perfect, able to keep their whole body in check.

James 3:2

SESSION 5

You have condemned and murdered the innocent one, who was not opposing you.

James 5:6

ABOUT THE AUTHOR

Host of the popular podcast, *The Joycast*, Margaret Feinberg is a Bible teacher and speaker at churches and leading conferences. Her books, including *More Power To You* and *Taste and See: Discovering God Among Butchers, Bakers and Fresh Food Makers,* and her Bible studies have sold over one million copies and received critical acclaim and extensive national media coverage from the Associated Press, *USA Today*, and more.

She was named one of 50 women most shaping culture and the church today by *Christianity Today.* Margaret lives in Utah with her husband, Leif, and their superpup, Zoom. She believes some of the best days are spent around a table with amazing food and friends.

Join her on Instagram and Facebook @mafeinberg.

margaret feinberg

scouting the divine

my search for God in
wine, wool, and wild honey

STUDY GUIDE TWELVE SESSIONS

Margaret Feinberg

Critically acclaimed author of *Fight Back with Joy*

Pursuing God

COUNTERING HIS LOVE AND BEAUTY IN THE BIBLE

SIX SESSIONS

REVELATION

extravagant ho

STUDY GUIDE + STREAMING VIDEO

MARGARET FEINBERG

52
DEVOTIONS

MORE POWER TO YOU

DECLARATIONS TO BREAK FREE
FROM FEAR &
TAKE BACK YOUR LIFE

MARGARET FEINBERG

HarperChristian
Resources

Discover the Beauty of God's Word

The Beautiful Word™ Bible Study Series helps you connect God's Word to your daily life through vibrant video teaching, group discussion, and deep personal study that includes verse-by-verse reading, Scripture memory, coloring pages. Get ready to receive your own beautiful Word from God.

In each study, a central theme—a beautiful word—threads throughout the book, helping you apply Scripture to your daily life today, and forever.

IN THIS SERIES:

Jada Edwards

Margaret Feinberg

Lori Wilhite

Megan Marshman

Lisa Harper

Each Bible study INCLUDES STREAMING VIDEO TEACHING available on StudyGateway.

 HarperChristian Resources

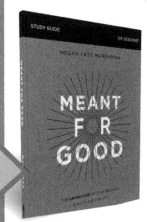

From the Publisher

GREAT STUDIES

ARE EVEN BETTER WHEN THEY'RE SHARED!

Help others find this study:

- Post a review at your favorite online bookseller.

- Post a picture on a social media account and share why you enjoyed it.

- Send a note to a friend who would also love it—or, better yet, go through it with them.

Thanks for helping others grow their faith!